Additional Praise for *Chaos Theo*

"In *Chaos Theory for Beginners*, Ro
turns quantum physics into a surprisingly accessible lens
through which we can better grasp not only our relation
to the larger universe but to ancestry, interpersonal
relations, and the unconscious. Characterized by
an affective echoing of sounds throughout myriad
associative insights, the poems in this book confirm
Broatch as an inimitable no-nonsense romantic who
intuits the dialectical advantage in examining doubt and
secular revelation. While employing the logic of a ghazal
in the confines of a sonnet, extended metaphors within
surrealistic imagery, the staggered discernment of visual
caesurae, or simply the direct impact of a musically
resonant statement, the poet is always a brilliant
conveyor of the hidden worlds sequestered behind the
first scrim of existence. As she says in one poem, 'We
need evidence / sometimes to know we exist, an observer
to gift us whole / and holy.' Whether rendering the
implications of the night sky, the love of a partner, the
history of a discovery, the absurdity of contemporary
politics, or the blood-links to our past, Broatch is in fact
that affirming observer."

—Kevin Clark, author of *The Consecrations*

Chaos Theory for Beginners

Chaos Theory
for Beginners

Ronda Piszk Broatch

MoonPath Press

Poetry
ISBN 978-1-936657-72-8

Cover art: *Butterfly Whether* by Ronda Piszk Broatch

Author photo: *Self-portrait with galaxy* by Ronda Piszk Broatch

Book design by Tonya Namura, using Armada (display) and
Minion Pro (text).

MoonPath Press, an imprint of Concrete Wolf Poetry Series,
is dedicated to publishing the finest poets
living in the U.S. Pacific Northwest.

MoonPath Press
PO Box 445
Tillamook, OR 97141

MoonPathPress@gmail.com

http://MoonPathPress.com

For all who gaze at the stars,
and imagine.

Acknowledgments & Gratitude

With gratitude to the editors, publishers, and staff of the following publications in which poems in this volume, sometimes in different form, were first published:

Cloudbank: "Butterfly Whether"

Crannog: "In Which You Give Me Such Words to End With"

Barren: "Because We Need Saving, I Consult My Quantum Universe Splitter"

Birdcoat Quarterly: "After the Sky Falls, All Our Small Histories Are Ruffled"

DIAGRAM: "It Was No Accident," "Searching for the Theory of Everything with Twine and Tweezers," "There Are Dimensions No One Knows the Names Of"

DMQ: "Sonnet with General Relativity"

Elpis Pages / Womanhood Anthology: "In the Ocean of Lost Belongings"

F(r)iction: "Because I'm Ninety-Nine Point Nine Percent Empty Space, You May or May Not See Me Waving," "In Which You Step from Your Body, Become a Cosmic Ray," "Under a Blood Wolf Moon"

Glass Poetry Press: "Let Me Be Breath"

Hunger Mountain: "Gravitation Cannot Be Held Responsible for People Falling in Love"

JuxtaProse: "After the Singularity, She Breaks into Infinity"

Missouri Review: "And We Arose, and Were Renewed," "I Make Believe an Imperfect Sonnet Can Save the World"

Pacifica: "Night, and the Coffers Are Empty," "If I Drink the Violets"

Palette Poetry: "How We Glitter Up," "Shebang"

Pine Hills Review: "Having Lost My Shoes, My Feet Learn the Discourse of Temporary Things"

Poet Lore: "Random Variables"

Prairie Schooner: "For Several Years I Prayed for Light"

Presence: A Journal of Catholic Poetry: "You Asked Me to Write a Poem About Hope"

Psaltery & Lyre: "Passion Theory"

ReDactions: "The Photographer Who Made Sense of the Universe," "Upon Discovering She Is Irreversible"

River Mouth Review: "Sometimes I Tell the Universe This"

Speckled Trout Review: "Beyond McCurdy Point, the Singed Mountains Smolder"

Split Rock Review: "When Our Stories Meander, the Eagle Comes"

Sweet Tree: "Covid Anniversary with Possible Weather"

Tahoma Literary Review: "Chaos Theory for Beginners"

Tupelo Quarterly Review: "Stop Me If You've Heard This One Before"

Typishly: "Here, With You"

Verse Daily: "Bargaining with the Universe, I Look for Loopholes," "Upon Discovering She Is Irreversible"

Verse-Virtual: "From This Small Spot on the Good Earth"

Whale Road Review: "Ash Wednesday"

Wild Roof Journal: "Even the Night Ocean Seems Like a Small Universe"

I'm grateful to the Centrum Artist Residency Program, and to the Whiteley Center for the time to write, and the space to tape poems to the walls and windows, to spread them out on tables, to discover each small solar system within the larger galaxy.

So many of these poems came to life with thanks to Kelli Russell Agodon and Martha Silano. I'm grateful for our weekly 2020/2021 writing sessions via Zoom with virtual wine and snacks, and kickass poetry exercises. In that first pandemic year, your community was a godsend.

To Sharon Bryan, heaps of appreciation for seeing what I could not. Your good guidance and insightful ideas gave me the opportunity to envision this manuscript in a new way. Thank you.

Thank you in no small part to my dear friend, Donna Green Van Renselaar, with whom conversation about the nature of things proves that electromagnetism is indeed a property of spacetime, and testament to an enduring friendship that found its roots in Nelson Bentley's beginning poetry class at the University of Washington all those years ago.

I'm grateful, too, for the camaraderie, humor, and wisdom of the First Sunday Poets: Risa Denenberg, Lauren Davis, Jayne Marek, and Kelli Russell Agodon. I'm proud to be in company of such all-star women poets.

For poet friends who participated in the daily Grind where some of these poems first dipped their toes in the cosmic waters: Jeannine Hall Gailey, Melissa Studdard, Kelli, and Martha, your presence across the expanse of the web was indeed a light along the way.

I would be remiss if I didn't thank some of the muses of the physics world—quantum and cosmological—those living, and those whose inspiring energy continues to feed the Universe, even after their particles have ceased to coalesce, (and in no particular order): Rosalind Franklin, Brian Greene, Neil deGrasse Tyson, Marie Curie, George Smoot,

Vera Rubin, Stephen Hawking, Nils Bohr, Lise Meitner, Albert Einstein, Roger Penrose, Max Planck, Edwin Hubble, Arthur Eddington, Galileo Galilei, Isaac Newton, James Clerk Maxwell, Erwin Schrödinger, Werner Heisenberg, Jocelyn Bell Burnell, Amelia Fraser-McKelvie, Katie Mack, Caroline Moore, Richard Feynman…

To Lana Hechtman Ayers, and MoonPath Press, thank you for bringing this second collection of poems to life. I'm so grateful for all you do, as a stellar poet and publisher.

Thank you, thank you to my family and friends for understanding my need to create is written into my genetic code, and for following along on my journey at different points on the continuum.

And my love to Rudy, Fiona, Duncan, and Lisbeth. Always and always.

Table of Contents

III

IV

Chaos Theory
for Beginners

I

We adore chaos because we love to produce order.
—M. C. Escher

I accept chaos, I'm not sure whether it accepts me.
—Bob Dylan

Chaos Theory for Beginners

Listen there is yet a chance at madness to become
the lioness in a field of moon lilies for words to push

up from the known deep grow gills form feet wing
through water's skin We talk of doors but really

we are only breaking walls Listen your eyes are so sky
in that hurricane dress the hugest two moons I've ever

Everything's happening so slowly fast it's hard to discern
who needs repair and who is just mean enough

to survive I mean isn't chaos merely a loss space-
defined the names of all the birds floating up

like sheets freed from their lines and aren't we all
standing here on that flattest piece of earth shielding

our eyes in our stormy clothes lilies at our brows
stirring a little heat beneath our skirts just jonesing to rise

I Didn't Realize the Door Was Unlocked

I have a habit of walking into new solar systems
before opening time. Maybe the construction workers

are still in the process of construction and I'm the one
at the door, checking my watch. I have a habit

of arriving a bit late, leafy foliose and shrubby fruticose
lichens shingling my hair. I'm in the groove,

following the light, chasing sparks started by minor
super-positionists, getting caught in the maelstrom,

a victim of overwhelm and over-booked.
I've got a routine of drinking

too much kombucha and staying up late
unraveling the cosmos, getting tangled in strings

so small my size 2.5x readers can't do the job.
I'm addicted to fitting God into the blueprints,

sure that *someone* had to be the first one to invent physics,
teach it to obey itself, to divide and multiply,

meet and coalesce. I'm habitually walking
into cell walls, black holes, confused as ever because

someone's got a penchant for rearranging the furniture,
someone is always trying to pull us apart.

How It Began

And everything outside you / is also you...
—Rena Priest

Nights, when I was a young astronaut-in-training, alone on the wrinkled grid of my bed, I recited the names of the nine Planets in succession. Such exquisite inventory: Mercury, nearest our Sun, backward-spinning Venus, my own Earth. Mars, barely a year away. Huge Jupiter with its stormy eye, the hula hoops of Saturn. Uranus, butt of middle school jokes, rolling along its axis like a bowling ball, blue Neptune's fourteen moons, and cold lonely Pluto, not yet knowing of its impending status reduction. Nights, I flew around the capsule of my room and through the window, rose above trees and city lights, higher and further, cool wind on my skin. Never enough, I discovered more than a solar system to build my life upon. Nights I pictured blurred edges and curves, learned of black holes and asteroids, that the galaxy held more than just my private dreams. To fly higher, I must lose ballast. Calculus, physics, astronomy, chemistry—those I failed—but never my wonderings, my beloved *how* and *why*, and from there, beyond God. What immense hand cupped such a nebulous vessel as our universe, the whole beaming seething seen and unseen undulating darkness, and at the same time held me, with my own complicated thoughts? I grew and hungered, stretching new sets of wings, but to no satisfaction. Nights, the universe expands, dimensions lie curled within myriad manifolds, electrons teem, tease between particle and wave, strings puppeting the four known fundamental interactions: gravitation, electromagnetism, strong nuclear force, weak nuclear force—together into one unified and impersonal God.

The Photographer Who Made
Sense of the Universe

She decides chaos theory belongs to a guest
class of stars and explains away the periodic table
to a linen closet of tablecloths and miracles

in skyfall gray. She imagines a future of champagne
and applause where dreams are remembered
by their presence on the tongue. Hard to swallow,

paradoxical at best. The matter of becoming wave
or participant? She creates minor entropies, carries
moon seeds in her pockets, chalks constellations

in anamorphic perspectives. The photographer
contemplates the moon's navel, the roughness
of the lunar face. She tips the universe like an hourglass,

sweeps each stellar remnant, each Planck-length bit
of glitter under the rug and pops the cork.

If I Drink the Violets,

you must hold the glass,
in case I become a fever of absence.
In my old version of creation,

our cosmos was birthed by another cosmos.
Which makes me fortunate, otherwise Johnny Rotten
would never have let me on his bus,

and I'd still be looking at my watch hours later
in tall fall grass, waiting for you to come.
The wheat aches for me

to run through it, tossing off jacket, pants, tee,
the bikini that slipped to show a nipple.
As for scissors, I'm never without them.

Round is the lip of glass, the pocked orange,
beautiful blue Neptune.
Show me a crazy overnight,

like the one where I lost at poker, and you
showed me your glittering icebergs.
The cosmos is still tumbling

its spent fireworks, blowing confetti
under our door. Even though you showed up so late,
I forgive you

your muddy Doc Martens,
looking at me
with your violets like that.

Retrograde Antithesis Theory

I'm in love with the medium who told me Jesus
is my spirit guide, that yellow ignites like a bee

hive. She says blue is my go-to, as in white-cherry-
blossoms-against-sky blue. I'm not saying we should wait

until moonlight to mow, that mulch isn't the love song
of worms. If the Milky Way is a five-hundred-pack

of suns, at least one store should stock Moon Pies
after dark. When I grow up, I'm running away

to Minkowski's Butterfly Nebula, winged bi-polar
rest home of ancient poets and rhapsodic rockers.

Freddie, I miss you, and Mercury's gone on a diet,
wearing its scarps like stretch marks. Still slim in that

skintight suit, is this the real life, or is this just fantasy?
The medium height stranger behind the moonlit mower

hides his secrets in tall grass, on the finely ground
glass of a telescope, and the tails of comets. Freddie,

your shoes would change the world! We wait for
your return, your footprints on the moon. When I

close one eye, you kind of look like Jesus
in a gold lamé shirt and black leather pants,

but still, I love the medium, still
I adore the extra-large.

I Make Believe an Imperfect Sonnet
Can Save the World

When you ask me to hold your glass, I withdraw my offer
of unlove. There are only so many ways to endorse

the universe, to become an exhibition of maelstrom,
a curation of distance and gin-smoke. Our home planet

pins up pain, runs drunk with scissors and howls
 when we turn
our good eye to the scope, fantasize about life elsewhere,

anywhere other than. Here is where spiders set up shop,
the reason we dowse our dead selves, one divine root

at a time. Show me your soiled fingernails and I'll give you
a heritage of hydrogen, einsteinium, and whatever begins

with a soft G. Show me your strong suit, and I'll give you
 my last
known tailor's name. Even god's been known to hide herself

in the gallery after hours. Somewhere in the far reaches
of my closet is a bottle, an escape hatch catching dust.

You Say Mistake, I Say Multiverse

Maybe the gigantic cabbage you thin-sliced, seemingly for hours, shoved the strings that kept swelling like the universe during its second inflation, crammed each squeaky slice into the two-quart jar filled with vinegar and starter, left it on the counter until bubbles were born like the first elements to appear, and when the new gasses slowed down, you put the universe that was the jar and its living strings into the fridge, and by and by we ate from it, and later tired of it, and the jar retreated into the far reaches of an ever expanding cosmos…and when its light finally reached us, we took it out and relegated the jar-shaped whole of matter-and-space, with its slimy cabbage-y threads, to the coolness of the mud room, and by and by tiny organisms formed and crawled from the ocean of sludge that bubbled on top, and a new generation began.

Night, and The Coffers Are Empty

—Mary Ruefle, *"The Jewel"*

When darkness seeps in I trim my wick,
keep my juices wrecked. These are the days

I live in a house of cards with vodka
and lime. It's Monday morning, I'm seconds

from sex, the Secretary General
of bourbon. I want to know what sets

your neon gasses alight. I want to take
the numbers off the clock and lose each

equation tethering time to zero.
When I play the song backwards I'm filled

with the thick perfume of gratitude. When I celebrate,
fog rolls from my mouth in shapes

of moths. This unbuttoned day's a card short,
a neutron star burning itself alive.

From This Small Spot on the Good Earth

The moon, drunk on honeysuckle took its time to rise.
Sometimes we need to rescue what we love in order

to marvel at it, reach a hand beneath its soft bones
and lift off. Call it self-preservation, how

I require the moon's approval, always taking her
portrait from the only angle she gives me. I seek

wisdom in a moonlit field, forgetting the unplugged
sun is the moon's loss. Perhaps I need only to stand

here, my camera's hunger unrestrained, letting it stray,
the better to capture what's so far distant. Maybe

if I keep what I love beneath my eyelids, love will
never leave. When the world goes toward its destruction

without me on it, my one sweet hope will be never
to fall through your fingers.

There Is a Rogue Group of Stars Behaving Very Suspiciously in the Milky Way's Disk

—Brandon Specktor, *Live Science, 27 September 2018*

One lifetime's not enough to spend wandering
the marshes on Mars, looking for shore birds, for shards.
When you ask me if gulls unnerved me, or if I feel

in concert with their flight, I steer the conversation
into a more horizontal dimension. Bring me

your broken-down galaxy, your wobbly wheeled
unicycle, and I'll share my picnic. I keep it
stashed in a ghost nebula. You tell me I ask

too many questions, and I must wholeheartedly
agree with you. You're the one who's always

popping bubbles while I try to hold down Hale Bopp's
tail. I mean, you were the one interested in dandelions
and dahlias, while I pretended to understand

the transient nature of stars. We can't all be bright
forever, you see. Or so you've told me often enough.

I keep my sun shadows in the back of my car,
my eclipse glasses in my wallet because you never
know who's leaving earth next, and how explosive

the light. If I could go to the Cigar Galaxy, I would
not, because I remember how sick I was the last time

I smoked a galaxy. My oldest told me several times
I can't like this, and I know she couldn't. One life
is not enough for seagulls, because I haven't seen

them all. The rumbling in the gullies has ceased some.
I doubt even Jonathan knew when he'd flown too far.

Sonnet with General Relativity

Maybe this is the century for rapture, or execution.
Maybe deep down inside us is an illustration

we can refer to, some clattering word or casual
meme to quote on twitter, or wave file of a nightingale

in the bluebell woods. All night in dreams I was floating
like a crow in catharsis. All night the darkness stirring

the fine bones of my ear. Maybe it's the age of primitive
visions, a return to ordinary time, an epic rescue of history

or just silence with the beloved. Hold my hand,
I ask you, before we make the leap into space, bring a lamp

and a wristwatch so that if we drift apart, I'll have the courage
to watch time slow, knowing you'll be older, more perfect

than the roses I planted in our garden lightyears ago,
when, bound by attraction, the better part of us knew to let go.

How We Glitter Up

In the upcoming years, or evening skies
we acquaint ourselves with slow deaths. We are outer
satellites, crazy copper bodies allowed to keep

our gasses. It wasn't our fault, this complex interaction
with the atmosphere, it's how we angle ourselves
above the horizon. This has made conversation

brief; following Io around its orbit, how ocean currents
carry huge amounts of Sun's energy. Jupiter was
so damned hot, but we said nothing. What

is the catastrophe of experience? I could not
match your brightness, your strong magnetic field,
your fist held in front of you like a lantern

inextinguishable, and flashing
either side of this invisible celestial path.

In Which You Give Me Such Words to End With

When making a bird with two hands it takes an ounce
of promise and yards of remembrance. I promise

I'll only tell you stories you might take with you in times
of dire need. The bloodstream fed thus will carry you far.
At each crossroads, in fields of lavender, under a sky so vast

clouds languish, we stop to clean our rifles, throw away
the bullets. Gather up our dearest conveniences and tie them

to the barrels. What must I do to convince you that there are
yet thirty-seven weeks before the coming winter, that there's
still time to plant and cultivate our transience like lovers

storing up treasures to be forgotten along the way.
It will be years and years of birds, yards and miles of walking

before what is worth having comes to our minds,
as the prisoner, before smoking his last cigarette understands
that there is more than just a train track, or teasing woman

to grow wings for, where each bullet unpacks its powder
like stardust.

II

Exploring the unknown requires tolerating uncertainty.
—Brian Greene

All you are is a bag of particles acting out the laws of physics.
That to me is pretty clear.
—Brian Greene

This Morning It's Like You're Wearing a Bad Wig

—Ellen Bass, *"Morning After"*

I hate the clock, you say. This is how
it begins, so much thorn, a nova exploding.

All before midday meal. *It's not about love*,
you say, a mouth full of French fries. I say *blame*

the fractured stones. You roll your eyes. The body
is a canvas. First, God took us by our feet,

and I think of the now bulbous heel, rootlike
broken and bunioned toes, how God held us,

then, speaking our lives in some foreign tongue,
dropped us wailing through the clouds.

You start on your salad. *Just about everyone
is stupid enough to get involved.* I think the bird

sings for itself. She knows full well
how long the soul means to stay.

It Was No Accident

I can no longer read the menu of stars.
Attraction curves toward the event
horizon and I've lost all power to resist.

I tell the sudden crowd sprouting from
a hillside to watch the burning house,
the tiny family huddled around the flames,

at least we've got each other. When my father
crossed from illness to newsprint blurb
at the speed of denial, I learned dying

has its secret litany, dark bag of thirty
silver coins. Scattered, they form the Greater
Omen Galaxy, the Hanging Tree. It is

no accident I'm fond of fire, of stories born
of war that end in redemption, of street
abductions that resolve into flights from death

camps to a new world. My body is full of nucleo-
tides and I'm constantly being washed up,
tumbled and helixed, in the act of uptake

into Ashkenazi roots even my father knew
nothing of. I'm thankful for Rosalind Franklin,
X-ray crystallographer famous for Photo 51,

her posthumous nomination by Watson
for the Nobel, how her namesake now roves
autonomously across the Martian surface.

It is no accident the more I read, the closer
the point of no return looms glowing
where before all was black, like the eye dead-

center of Messier 87, only fifty-five million
lightyears away, earth the first Event
Horizon Telescope, my father somewhere

on the other side, turning silver into light.

Sometimes, I Tell the Universe This

is how events will unfold: the eagle
will catch the salmon, or the salmon will live another day
nearer to spawning, evolve as sustenance

for resident orcas who are diminishing
in astonishing numbers. Sometimes I tell the All-One
No even though my mind

dangles before me this or that prophesy, that I,
being a part of every living thing declare an equal
say, and that I say *No* I will not succumb

to exploitation, become statistic on the planet's
list of casualties, not lose my life my dears my loves
to extinction, or the mutterings of deniers, that hope

is a choice I make, that somehow—and by this, I mean
I will it so—the waters will cool a little, the salmon will
thread their way, creating redds in all the rivers, orca
young

grown to mate to flourish to teach us their wisdom
before time stretches its elastic to exhaustion.
Sometimes rise doesn't have to mean

sea level, but rather rebellion and compassion, means
stitching rescue to our breast pockets, weaving time
into lifelines to each wild and fragile body.

In the Ocean of Lost Belongings

Sometimes when I feel beautiful
I comb the beach, looking for the scrim
of denial, but it burrows into packed sand
wet with clams and geoducks. Truth be told,

I am an owl on a starshine day, an open
window, an eyeless mask in gilt. Guilty
here and now, fixed between signposts past
and future, my pockets full of God stitched

with hummingbird precision. Sometimes I lose
sleep. Does she have her rain boots? Does he
have enough sugar to sweeten his blood?
I sometimes doze when the ship goes down.

The day I washed up in an ocean of loss
it was my starfish mind I missed the most.

Butterfly Whether

Because a wing-flap caused the typhoon,
the moon loses sleep, its thoughts spin as the sun
 puts earth through its paces. I try to say desire

 but it's only right to concede that I am
 wounded here, maneuvering straight

 to the center of my pain. I could say my heart is so dense
it sinks, but honestly, it's an empty fist, a hive
 deserted because the bees were tired of working

 the early shift. This morning is a silent street,
 a curfew rescinded, a snow day. I once touched

a Rembrandt when no one was watching. My fingers
loved the knowledge his hands worked ink into this very
 vellum that might now recoil the sooner for my graze.

 Now tell me to touch the tongue of a wolf, stroke it
 slowly to keep the wolf's teeth from snapping. Light

 is made from so many quantum points that I might cry
if I don't withdraw my caress. So I don't drown, let's
 retreat to a library of ice cream, where secrets melt

 slowly like love does, like when I wore a dress
 and nothing else to dinner. I call the cocktail *Nina Simone,*

 tell the earth that I live on spin and green lights, rain
that heals after months of heat. When I was the arms
 of a starfish wandering away from the body I loved,

I became a parcel of sorrow, a sparrow calling the bees back from beyond.

After the Sky Falls, Our Small Histories
Are Ruffled

We've all been saved. The crows lord over their flyway
from here to beyond the trees grown tall, shiny assassins

looking for young to steal. Such holy ruckus under eaves,
lulled by jasmine bloom, blue eggs broken to such hunger

as this. Saved from cats who wait at the windowpane
all eyeflash and chitchat, two mouths full of tines. Any given

moment I'm haunted by disaster and courting wonderment.
I am an exaggeration of wants, skinful of Malbec. To be

witness at the crossroads of so many lives, to watch
how loss grows underfoot and carries us forward,

because somewhere a child is being born and someone else
is mapping the distance to the star for which she is named.

The crows know us even when our masks are pulled down
over our faces, shards of blue cutting deep into our palms.

In Which You Step from Your Body,
Become a Cosmic Ray

No returning now, your organs are
confetti, skin splintering

meteoric. Maybe you should've taken
precautions, not gone so transparent.

Sometimes, you dream of dying without warning.
Sometimes you are a savagery of fireflies.

At times you heed the pavement's tug,
all those small stars digging beneath dermis,

you, falling from the curb, rush hour whizzing by
like so many photons. Observing gravity,

you push your Leica aloft, limp to the Blue
Moon for a beer, tweeze untold scattershot

particles from your thigh. Such a relief
now, floating off the crust, such beautiful

ambivalence, consigned to radiance,
breaking out into cloudless unending.

A Problem of Substance

Ordinary matter is what we are all made of.
 —Neil DeGrasse Tyson, *Astrophysics for*
 People in a Hurry

My matter is concerned with what's greener on the other side
of this bonfire, what foxy elements ignite life in some stretched
crease of a Calabi-Yau manifold, what great methane lakes

conflate on Titan. It takes a bit of moxie to dive through
scaffolding, put Newton to the test. My matter is concerned
with preserving the status quo, even so, I pack a talisman of

hibiscus tea and a bear's tooth swaddled in Kleenex.
What's humanity these days but an inconclusive experiment,
unfinished canvas painted over,

a cocktail blended so many times it's proof can no longer be
proven? You ask for enlightenment—a side hustle of mine—
but I'm afraid you hike in vain. If you promise to walk away

backwards, I promise not to bogart the light. On the other side
of this burnt apple is a worm hole affords us a way through,
and all the caramel-dark energy we can sink our teeth into.

Little Death Song for Grace

Spooky how the quantum camera captures ghosts
in the tangy non-light where photons dance,

imprinting in inverse language the beloved
unseen. Spiritually speaking, though apart, we

entangle even as our voyage transports us
to different camps, always in a constant

state of arrival, spinning in concert, lovers
on different wavelengths. Ash-wife, our paths

diverge. I manifest you electromagnetic
and inescapable. Sleep torn we trudge, light

deficient prisoners in leitmotif, our bone bags
gone threadbare, unstitched, ration sacks hiding

hard parsed crusts of weeks and months. We are soup-
stoned, untranslatable by any other means.

By the Time I Woke Up, We Were Still Everywhere

What is it to endure—more than—
to connect with a tightrope revelation

and revolution, forgetting all the holy
warnings? We imagine ourselves small

knots in the cosmic quilt, a collage
of collapse and haloed roundness,

escape, and craving. I drank my name
though it stained my lips, filled me

with spine. What is it to forget
beyond finishing, live outwith the slippery

constructs of the spatiotemporal,
a thousand deaths in a thousand

hard-sewn dimensions? The cigarette
bargains with the gun, the blindfold

with the observer. Imagine now
your disparate selves converging, particle

and wave arrested, on a single [.]
Know it goes on like this:

Dispatch from Mars

Today's flight's better, a little more zig
than zag, a perfect landing. Percy took photos:
the rocky terrain, Ingenuity's shadow,

how from below, she looks like a crane
fly. Maybe someday someone will plant
dahlias on Mars, create a way for rain

to fall. I know sometimes we need a little help
to stand straight, gravity getting us down.
Everywhere

I see possibility, lakes where rock upon rocks lie,
strange trees and colorful plankton
lighting up ponds beneath. I promise

my first persimmon to the first tourist to set foot
in the red dirt. Sometimes I work backwards
because I've gone too far ahead. I ache

for a different weight of time, a little lemonade
while watching the sun set,
Phobos and Deimos as they rise,

lumpy and irregular—not at all weeping
and beautiful as earth's sweet moon. I promise
permission to wander while you eat

your persimmon, the juice slow and heavy
on your chin. In the Martian morning
we can watch Ingenuity fly a bit higher,

like some overgrown mosquito, little antennae
poking out like feelers. Even now,
Percy makes a little oxygen

for the first time. It's true that joy comes
with different bodies, and it's not impossible,
even wearing a spacesuit and boots

to go back to the beginning,
grab a handful of dust, and dream.

Even the Night Ocean Seems
Like a Small Universe

The bowl on the table's got nothing to show.
Planted planets of peas have all flown off,
consumed by towhee, or my dear friend's Douglas

squirrels. My heart womb, dizzy and wisteric.
I meant what I said, spell what I can't describe.
Every day the moon rises later, fatter.

Honeybees thwap the glass behind which sorrel
and borage pop their limbs through potting soil.
I don't always know what women keep

in their pockets, nor the percentages
possible, the power of patience needed
to paper the politics of pockets.

The bowl holds problems personally.
The heart, the moon in the sun's womb.

Sometimes fire nourishes the ocean deep.
Sometimes I disappear for many billions
of microseconds, and sharks never sleep.

The bowl agrees not to hold those sharks.
Moon scythes a cherry blossom sky, and stars
coat the ground beneath my tree. Mackerel

scad undulate in bait balls through which sharks
thread. My heart is volcanic glass, a blown
bowl. All my atoms lean together in

appreciation, rearranging fish-
like, and like fish, I mean to tongue your every
barnacle. Sometimes lovers' pockets fill

with laughter, lovers losing themselves on
library ladders, literature and late
spring ladybugs limitless as galaxies.

My heart is a tiger shark, Hawaiian
monk seal, the mouse crossing my path.

Tonight, the clock that is my heart misses
a minute. A bowlful of fish scales, planets
where what we wish to plant always takes root.

Ash Wednesday

It is said there are over hundred billion quiet black holes
in our galaxy, but I can see past the smudge

where water and ash meet in the bowl before the priest
thumbs a cross on my forehead and I wonder if nebulas

stretch their light, send out photons to the four directions
of our earthly compass. But lately my three-plus-

one dimensional mindset's been reset. Forgive me.
I didn't see what curled in front of me, I was busy

reading, and paying the light bill. Forgive me,
even now I've forgotten the weight of ash. It is said

for these forty days we're invited to look in-
ward, to the depths of our hearts and also out-

ward to our neighboring stars, those to whom we nod
and pay little heed. Forgive me. Maybe now we can rub

the ash from our skin, scrub what we've neglected from our
windows toward a clearer view. I'm sure there are
 dimensions

within me, waiting to be uncurled, tendrils, little branches
seeking light, while at the same time blessing dust.

III

In all chaos there is a cosmos, in all disorder a secret order.
—Carl Jung

*…the universe, by definition, is a single gorgeous
celebratory event.*
—Thomas Berry,
The Dream of the Earth

The Origin of the Entropy and Temperature of Black Holes

These are the terms & conditions, your seven-minute generator, free & fast, and legally binding. A posteriori observation, probable cause. The origin of supermassive black holes remains an open field. Growth by accretion of matter & merging with other black holes. Mysterious disappearance? The universe has your back. Glossary of astrological terms, Pisces eminent personalities, like Einstein, his last words spoken, lost to his nurse. Astronomers have a new model of these impossibly primitive cosmic monsters, & these monsters—heavens to Betsy!—are real. Such stars defy love, deify lasers, say we're an off-guard definition, a synonym, but right on point. Find you a storm cellar or a movie theater, a job sitting cats, cataloguing guidelines, natural processes. What if the sun exploded? What if we've been seen? If there was no moon our days would pass in a blink, our lives spin a little faster. Us, spending our time ducking, every little fragment ringing & ringing as if someone blew up the dark.

When the Universe Throws a Party,
We Forget to Bring a Gift

The moon isn't itself anymore. Every day another
heavenly body discovers itself, and we are late to the soirée.
The Major Prediction Nebula dwarfs the Minor Portent
 Galaxy.

What panics us anymore, now we've named every form of gone,
and the last probe crashes into the eye of a solar storm?
We light lamps on horizons, watch from the sideline

as a black hole tangles with a wormhole. Nothing new
happens anymore, now the streamers and horns,
tiaras and ballgowns have been discarded.

The chicken and the egg met one day
and concocted a theory. The egg said to the chicken
let chaos be born!

On the entropy spectrum the arctic caterpillar's legacy
of freeze/thaw, freeze/thaw ad infinitum was determined.
Seven years its sentence on the leaf, then encased in ice.

The other day a briny ocean was found on Ceres.
We choose the darkened boat for sleep, take our whisky neat.
Some choices are easy, like

who will unprepare the wildfire smoke, and who will re-
ink Pluto's heart. Some days we marry our twin selves.
Some days we fall into another dimension,

punch drunk and nevertheless. The shape of a kiss
is not too dissimilar to the Pillars of Creation. Everything
that hasn't been brought to light will find a candle

on the bathroom shelf. Our one greatest hope
is to dance on the moon's more beatific
and gone-gorgeous side.

The Cellular Level of Oblivion

I'm writing to you from.

Because my knuckles wrapped the door the night of the
 bullfight.
Because I gently scraped the pavement, lifting roadkill

the way I rescue the drowning worms.
Years of dreams.

The least ribs of me remain half facts. Bootless,
I hold heart at the cellular level of oblivion.

I say bring me something from the sky's narrow end.
I went mostly clamorous into madness

with my hand in dirt, those honey days, training
my shaman-mind.

Today the sugar dollar is up one hundred points.
The sand hungered for hands, believed the singing mouth.

For that, echoes must be pitied.
Open the bottles of holy dyewater!

There's sweetness yet upon the butterflies.
All the rolling angels and their celestial horses

riding under the shooting stars. Once a father loved
the winged investor, her star-shine teeth, her guess-eyes

green-billed and grooved. It's a blue Eden, but remember
the seven things between nebulous and nil,

the bridge aswirl and transparent. I don't sleep
until such sparkles nightmare my dreams, kickstart

the trillion hummingbirds into existence.
These daily throngs push our shadows together

like breath curled around the jazz grass,
full of the pulse of young country galaxies,

every injustice angel crossing synaptic
into worthy time, praising.

There Are Dimensions No One Knows the Names Of

In the beginning was the holy
bang, all angels, orcas, humans, starfish
ringing by the millions. Listen—

they are bells shaken by the Universe,
sounds woven into each being crying
to be ordinary. *Look up*, says the sky,

it isn't true you are known solely
for your shell. Let ourselves be wound
back into music binaural and isochronic,

spherical and hopeful. Here, this boat drifts
over moonless water into inky beginning.
There, on the horizon, do you recognize

your first sacred love?
Send me there, says the soul.

Because Saturn's Rings Are Made from Halos

*When you form a star and its disk, it's not a very
easy, breezy process.*
 —Alice Booth, *astronomer at
 Leiden University, Netherlands*

Angels move around and between us,
 quantumly.

I want all my heavenly bodies surrounded
 by halos, the planet-making kind,
to come with life preloaded.

Show me the root of darkness and I'll gush
 about how mycorrhizal or myco-heterotrophic
relationships aren't parasitic.

St. Thomas Aquinas mused that *angels be not composed
 of matter and form.* Maybe our particles
are noncommittal, but see how angels pluck

syllables from the air, how they lie, beautifully kissed,
 as was said above (Article 2), *it follows that
 it is impossible for two angels to be*

of one species… I want to know about your
 existential dwelling, the cadence of Saturn's
fuzzy core, diffuse and pervaded

by helium and hydrogen. Did you know that
 the Armillaria ostoyae is 8650 years old?
Some angels are white forms of

the infamously deadly Amanita phalloides.
 Not all Polish doughnuts are super-Eddington
 accretion disks, but the terminus of

my week is filled with Prosecco plus stuffed Portobellos,
 jam filled Pączki, a love of the tiny crystals
 making platinum angelfish twinkly under blue light.

Stop Me If You've Heard This One Before

but the universe was always *always*.
So, too, were we, though on another branch
of time, you doubtless told me that, and I was likely

putting on my sweater instead of you
putting on your sweater, and I was the one joking
about Mr. Rogers, placing my shoes under the bench,

zipping up and then halfway down—click
click click—listen, did you hear it? The sound
of lift-off, the whisper of pears rotting

on a different counter in another wing
of Morrisey's fourth dimension. In that wing, I joke
that Stephen Hawking is winding backward

into his God-given voice, his mind yet remaining
beautiful. Are you cold? You must be cold. I think
the planets and the stars must be, too. Stop me

if you've seen this before, the moon
through tempered glass makes a cross,
and no, don't call the paranormal society

on me, or your local church, just rest here by me
on this bench, my shoes, or your shoes—in whatever
traded dimension this is—underneath, and we can be

small together, sitting here, watching the gemmy
dark, the glistening whelks of stars flashing,
Stephen out there, somewhere, telling us

I have noticed even people who claim everything
is predestined, and that we can do nothing to change it,
look before they cross the road.

Under the Universe We Find What Guards Us

Holy is a star we dig while Mother Saturn looks on.
What lifts us to the moonrise like lambs, fragrant

as ghosts with their hands in our mouths,
the clock flashing 11:11 every time you look at it?

A strand of me is always catching on crab apple twigs,
wrapping loss like a spider's trapped fly.

Once, there was a nameless molecule,
a glimmer in an ancestor's eye.

What ties itself to telephone poles where the bear
scratches her unreachable itch, is the itch itself.

Mars is now in high density, and zodiacal light
has been solved by Juno studying Jupiter.

The bear wasn't disturbed when I stepped through
the window to get a better photograph.

The bear was ringed with stars. I recognized her as God
of my most pressing life.

In the rockery bloomed the first grape hyacinth,
inside the dead bird was the seed of a dream realized

in another dimension. I can't be afraid of the future
when there are bears by my side.

Days we spend flexing our souls like pipe cleaners
and bendy straws. We hold them up for each other to name.

For Several Years I Prayed for Light

invoked photons, not knowing their poetry.
I asked *is this cheating?* You tell me

I'm overlooking the point, boring through walls
with a straw. Just to see some small bit

of radiation or stardust ghosting the edges
of darkness, I'd slice a live wire to feel

its sacrifice of me. What applause drifts through
the church window on a windless day

and cleaves to my bones? Underneath the Ouija
are untold outcomes, as many as there are

universes awaiting a signal. Give me a flash
of inspiration, feathering the air, lighting up

my foundation. A little voltage, scarf of brightness
arching snakelike above me.

Because We Need Saving, I Consult My Quantum Universe Splitter

A photon leaves Geneva and arrives at one
of two conclusions in two separate universes.

In this one, your shorts are made of shouts and
my lingerie is dark enough to blot out the moon.

To make us listen, God scrapes her fingernails
against the dark matter chalk board, blows on

a blade of grass. If freedom was a door made
of jet screech, we were its shock-cell structures.

If the door is holy, we slip an envelope beneath
for God to read. In this dimension your miracle

is a devil in drag, salvation like a French kiss
in a galaxy of rhinestone, of universal peace.

The photon loves the partially silvered mirror.
God of foolish things, we say, *push the button.*

Ringing God's Doorbell Felt a
Bit Like Spitting

into a vacuum, or camping beneath the mailbox
during a snowstorm followed by a long holiday
weekend. In other worlds, God answers right away,

has two heads, has both of her mouths sewn shut.
My need is big as a haystack, and I am the needle.
Because God's doorbell is impossible to reach, I light

a fire under the soles of my feet. Because God's house
is big as the universe, the bell sound gets swallowed
up by black holes, much like noise cancelling head-

phones no bugle can penetrate. When I finally hear
God's voice, she's on the phone in another room,
her hair thrown back, a drink in one hand, the other

scrolling through Pinterest and Instagram on her laptop
while her cigarette slowly smolders down to nothing.

After the Singularity, She Breaks into Infinity

Always, something is breaking, birdcall brimming
morning, sun after rain. Ground in perpetual
wormhole discourse, presaging pickaxe, renewal.

Lilac fractals from an arm-thick stump sawn off
for its insistence in reaching the light. Impulse
innate inside us, we river through the rock

of us, rough thrum building years-long until
birthed, molten and new. Even burning won't
kill a forest, force it to lie down forever. See,

the seedling searches the frost-heaved crack
in the cemetery road, and next thing we know
we're on our own, another mother made more difficult

to trace. Even the stars have forgotten the God
who, at her breaking point, shook them loose.

Religion as Physics, or What We Wear When the Moon is Right

You're a little black dress, a dust-up, a sensation
of small bubbles, the irreversibility of a shout
once it roars from the diaphragm. Your white telephone

is my white elephant, and champagne is champagne
in any situation. My extra pair of pajamas has skullcaps
on them—is that okay? In blue stillness I don't resist

the alchemy of bonfires, but worry about the poplars
just yards away, standing guard against this August wind.
Whole communities of leaves! And I go to sleep instantly,

wondering, are we pillows, or just closet space? Maybe
you're the party girl with bones in her pockets, bringer
of blessings and praise, gold smudges on your thighs

like you just got done necking with God. Oops,
did I just say that out loud? I admit to giving away the belt
buckle with walrus tusks engraved on it. And tonight

there are comets whispering to the cherubim, something
about haloes, something about doorbells and loss.
Your pocketknife is digging into my achievements.

And your lipstick is stuck to my shoulder. Pardon my
moonbeams, the failure of my bottle rockets because
I dipped them into the merlot. It's your little black dress

populating my handwriting. Knife sister, desire is a wet
flea in the wine dregs. And you just sit there, smiling.

Upon Discovering She Is Irreversible

At any given time, she owns only a nub of lint,
a dark photo in a back pocket, eared and creased.

In a year of earthquakes, she learns a fondness
for the way nothing is granted anyone

but the forwardness of time. She tries to wrap
her mind around the second law of thermodynamics,

has felt her entropy wane, her parts pulling apart.
She wonders sometimes if she is a quick joke

issued from the throat of a truant God. Every day
her wool sags. Her thoughts, like burned out

filaments, follow her, cold coils blackened and brittle.
At any given time, the earth could whim, yawn,

could surge her power at the speed of expansion,
the arrow of time long past.

Covid Anniversary with Possible Weather

Rain coming down, chased by more rain. If you must
know, I'm a strand of the alphabet, throwing off sparks,

hoping something will light up and stay lit. Say I
open all the windows, let every thirsty thing become

drenched: the towels I just folded, the books and poster
of Einstein, my dad behind glass, the packing materials,

the cats. Perhaps I'm a brushstroke of that shade of gray
you can't name, and obviously you are a color slightly off

the spectrum. Put together, we could be shards
of the bowl I broke trying to reach the maple syrup

from the back of the fridge, behind the plum preserves
and leftover birthday portobello mushrooms in balsamic

sauce, now splashed on the floor, the fridge door, my pants.
The question is, how to rearrange the furniture,

the future, our footsteps, now the sun
makes its own kind of break?

And We Arose and Were Renewed

What should I believe in next, now we've deduced
ours is a passive God, who spit the seed and watched it

explode like morning glory? I know we can't feel it,
but we are coming apart, the universe of

our bodies expanding like prize-winning pumpkins
we carve for months of soup, leaving the crows

to fight for what's left. I believe in soup, and onions,
poems, orcas, life on other planets. Let's put faith

in emerging unscathed from a black hole, the ghosts
of our mothers having gentled from their journey,

their eyes cut out for science. I believe in eyes, too,
wondering if a pair can be passed from mother

to daughter ad infinitum, something like scales
falling away, the dying stars closer than ever.

IV

Yes, Einstein was a badass.
—Neil deGrasse Tyson,
Astrophysics for People in a Hurry

Ah, gravity—thou art a heartless bitch.
—Sheldon Cooper,
Big Bang Theory

Gravitation Cannot Be Held Responsible for People Falling in Love

Place me in the silence of Einstein's mind before he wakes,
inside the painted ear of Dürer's *Young Hare*, the interrupt

where chaos births theory. What worries me is the moment
the last blossom falls from the foxglove. I can forgive

the eggs boiled to incineration, the scorched pan scrubbed
of evidence to my wayfaring thoughts. I invite Albert

to share my breakfast, and we talk about the time I learned to
fly on my own, wingless and windy. I say sometimes

your energy crosshatches my life with a list of immediacies,
a basket of forgets. Can a crown change the way I walk

into the world? Can a dustpan? In the penciled light
I inform you. I forget to show my work. When the Great

Horned Owl becomes a panic button in the maple tree,
I wear a camera. When raven and crows announce

the apocalypse, I place my chair with a view to the limb
where this feathered god watches. Sometimes

I hold a headlamp to the dark, ask for the password.
Einstein's mind is full of anti-gravity, light matter, white

holes. Chaos rains butterfly fractals, and everyone is falling
in love with the softness of garden variety cottontails.

In dreams Albert sits at a quiet desk reading loud books,
while Albrecht's hare imagines its ears limned in sunlight.

Foxglove. Foxglove. Foxglove! he exclaims. Foxglove, not
phlox drew the hummingbird with its glove. In the stardust

deep in the pile carpet, the quantum word was born.
In the knuckled knock the stranger at the door

became known. Gently, Einstein wakes. In his hand
an eggshell, a parachute, two tiny ideas spinning

on either side of his vast mind.

Because I'm Ninety-Nine Point Nine Percent
Empty Space You May or May Not See Me Waving

On the road I might not see you wavering.
Because love. Just call me quantum harmonic
oscillator, a single spineless wave

weaving the blanks between champagne bubbles.
Because the solution is in the water between bubbles
and I hold the glass.

The glass, and what's in it.
Because life is nebulous, I hold one in my hand.
You need clarification: Nebula or life?

Because *as a cloud of gas and dust in outer space, visible*
in the night sky either as an indistinct bright patch
or as a dark silhouette against other luminous matter

it doesn't matter that atoms have their own secret
life we try so hard to invade. Because we are all small
pieces of God, and seabirds

are ever in the act of shaping sky.
Because this paper plate has a time limit, I trace
circles against its embossed and wavy edges.

Because time is and isn't a paper plate.
I beg to differ, and my father can return
dragging his leukemic body back

(from some other dimension) and my mother can collapse
at the sight of him. Because my loves come in dreams
to collect me. I see they have only slipped

into a world of candles and sun shadows.
Because Einstein reminds me
it's how we vibrate in this life that matters most.

Lambda of God

*Einstein first proposed the cosmological constant
usually symbolized by the Greek letter "lambda" (Λ),
as a mathematical fix to the theory of general relativity.*
—NASA

I confess I thought you held the answers.
I confess to my demons I hunger many mornings
for expansion, for salt enough to sate

but it never mollifies. I confess my intentions
zeroed. I confess my intentions shapeless
and persuasive. I confess I no longer felt

the Earth underfoot when contemplating
the purgatory of stars. I confess to my own tiny bang;
I never followed through, never professed

confessionally, deviated toward a poetic time-
warped god, God in a vacuum, prankster god
of the cosmological constant. Albert's monumental

blunder overturned. For this I confess I knew all along
even the shadow of Ziggy Stardust laughs back.

Dear Spacetime,

I have taken you for granted. Like the garbage disposal in my daughter's college apartment that ate a shot glass and left no trace. Gravity, a weak force propagating through space is but a mere feature of you. I stick my hand in, you distort. Einstein didn't get very far, what with wrangling his children, General Relativity and Quantum Mechanics, trying hard to convince them to play well together, speak a universal language common to many close siblings. "How much I have already plagued myself in this way!" he confessed in a letter. O Spacetime, you confound me. Someone once wondered if we could use black holes as garbage dumps, but honestly, I don't have the time to drive to Sagittarius A*. Pour me a *Celeste-Jewel Ale*, moon-dust steeped in fermenting beer, or a cocktail served in a 3D-printed zero gravity martini glass, with a little Space Oddity, a bit of Muse on the side. O, Spacetime, your atoms are weird. On closer examination you're hot and random, gassy and radical. Even in a vacuum with no particles around, your fields are internally entangled. When I deviate from my northward direction across your magnetic fields, even the slightest bit, you mix my speed with a little more time, until I'm dizzy, until all I see is light.

Searching for the Theory of Everything with Twine and Tweezers

*The universe is a vast expanse of space which contains
all of everything in existence.*
 —NASA

To make sure, I go back to the molecular, the quantum of.
Each strand of DNA, each small loop of proof that we

are strung somehow together, dipped in the same Ziggy dust.
Over and over, I wash ashore, filled with salinity, with fish

so microscopic I could be a universe. We need evidence
sometimes to know we exist, an observer to gift us whole

and holy. Too often we wait for news to cross an expanse
haunted by the constructs of time, wrapping its tendrils

around the warp of us. We follow our own coordinates,
avoid the event horizon, watch as those who flit too close

become the absence behind which light shines. To make sure,
I keep my shoes on the shore, eschew the salt of temptation

pulling me moon-ward. Let's recheck Einstein's numbers
just one more time, wallow in relativity's secure embrace.

Passion Theory

More than bread and wine, or at least arising
in time for church, we need a little midnight

sex, the chance to zenith as the blood
moon traverses the ether between equinox

and Easter. Everything sanguine. Everything
illumined to unmask our every crater, valley, plateau.

Once, barefoot, I read some sacred writ
in a sanctuary lit in votives, amidst basins of water,

spent towels, and the scent of lilies—
(my feet newly washed)—and instead of wisdom

I uncovered an ache so raw it wept
milk and honey. It was then I understood

that even a stellar black hole will emit
its own magnetic and devouring love.

It Takes Me Twenty Minutes to Traverse
One Side of Dactyl

You ask me what's falling apart, and I can only see
what's falling about. Think meteors, think cottonwood fluff,
the leaves I pressed fifteen years ago in the book

I open for the first time in fifteen years. Imagine
my surprise, leaves smooth and green-gray as the day
they fell from whatever tree they fell from.

I look to O'Keefe's bones, the opening in the pelvis,
the irises, and so far, only the hole remains whole
in my mind. So much interstellar dust! I've emptied

three bags today, and all I manage to find
is popcorn in my bra. I'm looking for a vase
for my dead foxgloves, my Jumping Jesus. I pray

for the icebergs, close-flying asteroids, my husband's
keys to return. Instead, the conversation veers, as it does,
to an uptick in pandemic deaths, the latest iteration

of Donny T's lies, and the nature of crows
when they've been denied their eggs for the day.
So much grief! So many starfish

coming apart at the seams!
To live like a human being is to see life at every turn.
To live life is, at turns, to see like a human being.

I call my ache Oumuamua, wait for it to slide by.
I call my ache Iceberg and pray for the polar bears.
I call my ache rusty gate and push it until it stays open.

You wear sorrow like a robin lost to the Great Horned
Owl, you cry cry cry for hours, then cry some more.
Did I tell you the leaves of the weeping cherry fall like

scales, octaves I can no longer smoothly play?
The mountain says to me, *I'll go steady with you*
when you traverse my spine. I'll give you wildflowers

and let you stretch your gaze. And tomorrow I'll go
into the forest, into foothills, following my feet, the call
of marmots, mice hiding in the foxglove's mouth.

In the night, the owl is a prayer of wakefulness.
In the night, coyotes sing glory to their prey.
In the night, I tune my ears to the dark.

Even in Theory We Can't Seem to Agree

The day we feasted on absolutes,
a new catastrophe was born.

There are limits to the precision
of what can be known.

The girl works the pump handle
as she was taught,

yet she brings up a new kind of water,
the surface tension of which
worries the moon.

As if the moon
decided to shirk attendance,
leaving the oceans

stagnant as engine oil
in a jug behind the shed.

All night my heart
makes its way in the dark,
following a trail of assertions.

As though death was a sort
of unraveling, we project our fears
into the nearest great void.

Full of stars and caution,
I pluck the girl
from a drowning constellation.

Uncertainty keeps Z's position clouded
behind X and Y.

Under a Blood Wolf Moon

How much galactic flotsam can one girl take?
A dollar robot in pocket, she is an alien

in this neighborhood. Turns out
not all things have counterparts here on Earth,

nor do dragons sleep after dark.
She gets herself wound up over the slightest

zap of high energy gamma rays. Pandora's Box
must've flung open, a dizzy ballerina

spinning and spinning, always spinning
until all a girl can do is close the lid.

She isn't the dragon, any more than you are
not the ballerina, nor the Cats Eye in Draco's

belly. We've all looked up in hopes of seeing
an asteroid crash into the moon. She'll wait

for the wolves, all nine o'clock and bloody
as sauce against the dark mutterings

of space, that electromagnetic black velvet
pinned up to hide the moon's wickeder side. She

sits cross-legged in a forest clearing,
takes out the robot and invents herself again.

Let Me Be Breath

give rise to mud birds whose feather
 flames exhale from hand-

held loamy ooze the word first
 uttered zoetic fleshy respir-

ation let me adjectivize the rising eman-
ation that delights the lens heaven-

bodies expanding coming
 together Hubble-loved color-

ized let me be inspired sucked
out black hole mystery we all wish

 to trip or at least a light
pffff that sets the seed adrift

and aren't we all just insufflate
 junkies jesus wannabees

glimmer lyricists resurrect-
ion addicts lovers of unwrap rollers

of stones holy wind blowers gaspers
 wheezing & flapping until we

everywhere exhale emanate
& up lift

Standing in the Pasture, Thinking About Quantum Entanglement

When dusk goes dark, I look for the space station
so I can wave at the astronauts as they conduct
scientific experiments above my head. I wonder

if acceleration helps them feel like they've got
firm ground under their feet when they're tired of floating.
Bright little island skyward. Then I think about

a pair of particles on their way to a party and one falls
suddenly into a negative energy black hole while
the other shoots off into space in a Hawking radiant huff.

I imagine all the potential good energy wasted
in black holes across the Universe, and I sigh.
Dear little particles, I say to them, *take heart*

and I wait for the space station to once again grace
my small patch of sky.

V

Physics is theoretical, but the fun is real.
—Sheldon Cooper,
Big Bang Theory

Anything worth doing good takes a little chaos.
—Flea

Fun Facts

Tell me how a God can step on such intelligent life
as the microbe! I'm not a master at theology, and my brain's
parallel construction is held together

by a mere thread of cognition. There are many more
than ten mind blowing factoids about black holes, like how
one can be 50 billion times the mass of the Sun,

and the non-existence of elementary beckoning violets.
How worried should I be that the lighthouse bulb went dark?
And how many Tom Cruise deep fakes are there? Go on,

tell me more about how intuition can only be leveraged
through practice, how we share the same umwelt.
So e. coli can travel as fast as a horse running

135 miles per hour. How Venus rotates widdershins
to the rest of the known worlds. Right now, I'm drowning
in unsolved things, distant citizen of Gondwanaland,

my babbling heart sending radio waves into the vast unseen.
Go ahead, I'm listening.

When Our Stories Meander, the Eagle Comes

mewling like a stone caught in a wheel,
the red-tailed hawk holds your eye
captive in its yellow one

until released, you return home, look up
what it means to be chosen by a raptor
in this exact slice of spacetime.

The bear scats berries and apple peels.
Show me the cipher that unlocks the wind
that wraps its invisible mind around

what stands immoveable. And isn't everything
quantum jittering, seething under its skin?
Don't say this isn't the same story

as the snow in the heavy sky forgetting it's fallen
for gravity, for earth and mountains and trees,
time beyond remembering.

When methane plumes bubble up
from Puget Sound's seafloor, it's just us
grieving into the mystery,

our hands tight around earth's tectonic plates
to keep them from wandering, only the curious
animal of us peeling the bark

from black holes, dipping our fingers into the dark
and unsleepy dirt to learn the ecstasy of earthworms,
hungry for illumination that won't break us.

It was the year of considering time travel,

and how to save the North Atlantic Right Whale.
Spring is ending, and SpaceX will tuck baby bobtail squid

and tardigrades inside its Dragon cargo capsule.
What I didn't realize is there might be thousands of tardigrades

already on the moon. Because octopuses are so intelligent,
a brain in each arm, eating them feels cannibalistic.
Some say the octopus is what an alien might look like.

When you say that aliens might not be interested in us,
I say I understand we have a lot to learn, a lot to undo.

There is dust behind the stars, some stiff-hipped moths
circling the drain of my poorly draining shower.
Without electromagnetic fields, gamma rays, radio waves,

we are blind. Imagine alien physicists doing calculations
in a dark matter lab. It was the year of reading late,

of conducting thought experiments, and getting lost
in seawater with cephalopods. The year of silver linings,
of watching the red disappear from my hair until it wisps

ghost-like around my eyes. If not for dark matter, what of
the aliens we so wish to contact? It was a virus year,

a year of feeling alien in our skins. If not for baby squids
and the myriad tardigrades drifting in the blackness above
our heads, if not for you, then why be dazzled?

You Asked Me to Write a Poem About Hope

And I can almost hear us jonesing to be thrown
into that long night, undiscovered planets orbiting
their stars as if there were no questions, where a new

prayer is a shortcut to grace. Nights when the moon
seems too accustomed to grief, we let our bodies
be the applause, the apple tree, the new marriage,

you, locked to me, me locked to you, forgiven
inside and out, where our wounds signify the time
we were born to, where magic doesn't need to be

forgiven, we see it for what it is, the orchid that sings
resurrection into being, the evening floating
like the opposite of storm, glad to be here again

and again, all our secret names written on the insides
of our eyelids, where broken doesn't mean done,
and even the ground under our feet rejoices.

Having Lost My Shoes, My Feet Learn
the Discourse of Temporary Things

Where I stand, I've stood before, morning dishwasher fed
and shouting that new ache that belies its quarter century
age. Just this morning

I stood here, like some garden grief, the larva of which
hasn't chosen yet particle or wave—yes, I feel that small
sometimes. I memorize the cracks

on every tile, the melodrama when the varied thrush thinks
it can fly through glass. There was once a girl
who went home to dinner. A horse

who followed me after we fell together in the sawdust.
In that moment we were both the idea of the particle,
the breath of the wave. There was a boy,

and he is our boy, who laughed as he walked backward
along the boardwalk, a moment where waves crashed
several rockfalls below, a second

where I stepped out of my particulate self to grab him. Oh,
the lesson you learn having claws, having skin.
Every morning I roam with stones

in my little matchbox. I float above myself, watching the
Earth align in spherical music with some unknown planet
like a dime aligns

with the correct slot. There is too much morgue these days,
too many statistics screaming mornings and evenings
on the news, too few forget-

me-nots fragmenting my free days, my freedom.
I've also stood long in the Museum of I Don't Know,
and its satellite gallery, Brain Not Working.

I keep remembering how the girl never made it home in time
for dinner, the photo in the paper, how she was met
by medics after darting between

cars instead of dimensions. Hello, I hope you are still here
to say *good boy*, hope, where you stood then, stardust
in your pockets, you live today.

Shebang

This is the ticket stub you'll keep,
wine in hand, dog unlaced at your feet.

When all that's left is the outline
of what was, seamburst of the Universe,

primordial nucleosynthesis, helium
deuterium lithium tritium beryllium

appearing for the first time. And what about
what's hidden below your cosmic clothes

and inside your rib-slats—what dog lies easy
in the milkweed while all around him hum ecstatic

reminders of a silent god you shattered
forth from, shards of whom you still hold deep?

Bargaining with the Universe,
I Look for Loopholes

Some bets are made of paper, and you are standing
in the rain. And when you found
a wagon wheel beneath the sod, propped it

against garden shed walls, you wished for cockles.
Morning glory twirls the spokes and this you call a bonus.
A button in the grass means you will live another allotment

of years, and the dandelion picked and placed in a bucket
without losing a seed is a confession
you won't have to confess. Let the subject be a cipher,

let the cryptographer come back to life just so
she might be thanked. The moon speaks a language
of wild onions and what is hidden is itself existence's

singular song. There's much I don't know, and I swear
I'll try harder yesterday than I did tomorrow.
Silence's cheap bones roll in the dust

after a good bleaching, and the cracks of our conception howl
with acuity. Is there anything that would save you, make you a
million times larger than a continent?

I also don't know many other things, but that an ache
is an event, a sandwich, a wish between two slices.
I saw how we, animals of surprise, could shine,

inhale the flowers and the wandering weather, lead
the meadow to water, and swallow every miracle we find
if only to save us from ruin, fill us with impossible wisdom.

Right Name, Another Address

Sometimes I think the planets fled from God's mouth and sometimes I take the moon's pulse when it wanes. Tell me who folded the telescope inside a horsehide coat, how the boatwright shook out his numb limbs, did a little yoga breathing beneath the stars. His engine cut, his boat glides over a forest of duckweed. Sometimes I think about not thinking, try not to hear the earthworms chewing, thunderclap of a squirrel's tail thwacking a branch. Today I opened a letter addressed to you. *Your own ears will hear a word behind you saying* "This is the way. Walk in it." Today I muddled the fried eggs until they became one with the spinach and sprinkled it all with moon dust. Chocolate often returns my memories. Strangely, my father collected empty packs of Marlboros. The letter goes on to say "If only you would pay attention..." I search for matches beneath the shadows of flames. The sky wrinkles around the waists of Douglas firs. Give me chaos, and I'll tie it to my wrist. My father eats pecan pie while wearing his brand-new body. Inside each kaboom lies a secret, and every so often I mistake Isaiah for Godiva, for the face within the ice cube. Mostly, all the planets fly by me, like a river to the ocean and I find myself in my nightshirt, butterfly net in hand, God's breath soft on my face.

Well, It's a Marvelous Night for a Moondance

And if I die alone in Amsterdam, please pen a poem
to circle the earth with my ashes. I hold joy

while the gin lasts, while the sun ignites crimson
Jupiter's beard against the muddy waters this side

of forever. To the swans in England, I say the sky
is your queen. I am in love with O and the weather

of sweaters, and everything I cannot type
with my right hand. I'm also infatuated with A

who wanders lonely as a cloud with a handful
of daffodils. Van, I'm cloud hidden, too, a sonnet

of minor universes and bottlenose dolphins in pink.
Cat first saw his own shadow in the moon's light,

and I wonder, with the stars up above in your eyes,
will you catch me as I'm passing by?

O, To Be Hollowed Out, Let My
Moon-Mind Shine

hard into the welkin, no drained-out flashlight, battery-dead
camera. And what do I see when I turn the lens
on me, and where did I put this homeless love? Hung it

over my sloughed antlers, velveted and rose-garnished.
All around me, forest and this orchard, apple trees
large as buses, and spitting fruit. My pockets stone-full,

seedless. Sit here long enough, another Liberty will fall,
and on the third day the doe and her fawns come to sup
sweet split meat. Because you heard the Great Horned Owl,

I chased the mourning dove. I've no inkling what it's like
to be washed up with the tide. Tomorrow this will be
no longer true. All night a child hollers in the woods,

and all night the silence covers its ears. I tell you
panic is plentiful right now. Now would be a good time
to be a wolf, a necklace of black birds unraveling

from a single feather. O, to be an elucidation
of appaloosas among the aspens! Right now, my moon
is hung and quartered, and the winds do howl

in the south. Somewhere windows are shattered like eyes
opened for the first time. Do we do what we did before,
or do we board up death like a hurricane house? The horizon

is so low now, I can't see to put my one foot in front
of the other. Meanwhile the headwaters rush sweet
into the salty brine. Oh please, I pray to the gathering

thunderheads like so many black birds arriving to a birth,
to a fledge, fill me with your slippery absence,
your fleshly light.

Random Variables

I walk into a tripod with a pasture.
The moon struggles some days just scaling
the trees. To make a place for death, I close
one eye. Say I'm giving you an ocean

of grass. A throat full of ululations. I confess,
to find the right words I reach for a book
on migration. There are fifty poems on how to trap
time with a closed loop, coax a bear

into my garden, how best to wear a Möbius
strip of swallows. There is nothing to see here
but detours, a parking lot of palm trees,
a question of bones in the shape of a fortune.

When you get right down to it, the whole river
of loneliness passed me by, and I'm sorry for it.

Unraveling Sorrow in a Tangled Multiverse

Let me hold the edges of your deepest sorrows,
dive my hands into the dark matter

of amnesia—that endless cloak growing, size of
the only universe we know. Did you know

we are all drifting further apart with dizzying speed?
Each galaxy a story already told by the time its light

shows up at our door. I want to stitch the Milky
skin, the only home we know, wrap its spiral arms

around me like the shawl I'm knitting, the one called
Nightshift where I'm juggling strands of *Entropy,*

Gravity, Wavelength, Neutrino, going from darkest
purple to *Aurora* green, *Pillars of Creation* red to gold—

I want to not let go of this yarn, to feel the soft
scratch of it on my shoulders, want to hold onto the itch

of the stretching cosmic fiber, tearing itself apart, same time
healing itself, holding in its energy bowl quantum jitters,

how gravity clumps and repels, how sorrow does
the same, our bodies proud with scarring, our thinning hair,

how I hope to remember to knit you a kindness
poncho, one you can count on, that will never cease

to catch you, no matter where you land on this
crazy continuum, this beautiful oblivion we call home.

When We Take the Moon into Our Ribcage

This morning there are only waves
and a single gull cutting space
between thunder, a cloud, and the departed

sun. Right now, I traverse
that line that silvers the shore,
barest of silken threads left

by retreating light. Sometimes
it's good to be blinded by contrast,
that gray doesn't always mean nothing

to see, dove against charcoal, slate
rubbing up against shale until our bones
writhe with the beauty of it.

Beyond McCurdy Point, the Singed
Mountains Smolder

I walk further along the sand, knowing
no bones or bits of glass will keep the light
 from fading. Behind me, moon and Jupiter vie

for my attention. Behind me, my cabin, an hour away.
 I am searching for time, to be ground and polished
by the Sound. Somewhere are the bones of a bear.

 To east and north, Venus and Mars burn holes
in the cloth, specks of glowing ash between them. Water
 strays, leaving orange starfish, small crabs pinking

near the upthrust of black rock. Such beautiful violence,
 this landscape, sea convening in furrows of sand, pools
enough for bear to wet her paws. Moon and Jupiter

admire the growing night, bear, her returning flesh.
 We call to one another as we walk.

Here, With You

How good to be lost
 with you, soaked in sunset,

two gulls threading the gray
 air, wood smoke and tugboat,

swaths of water burdened
 to a sheen. Maybe time is

merely a construct of our making,
 but I believe

in hunger, in being fed.
 In taking a lifetime

watching crimson spill
 over foothills, dousing

Puget Sound.
 I wonder what it's like to ripen

without fear, to be a near perfect body.
 I've heard it said

hot metal dropped in water
 forms a true sphere, held

in tension's embrace. How comforting
 to know when death lugs

at my life force,
 spreads my energy out into

so many billions of stars—
 such sweet amnesia!—

I will still be here with you,
 two gulls gathering the dark,

stitching closer, two tugboats
 pressing home.

Notes

In a nutshell, chaos theory "describes the qualities of the point at which stability moves to instability or order moves to disorder." —sciencedirect.com

The first line of "In Which You Give Me Such Words to End With" borrows from the title of the book *How to Make a Bird with Two Hands*, by Mike White. (Word Works Press, 2011 Washington Prize winner)

"Gravitation Cannot Be Held Responsible for People Falling in Love" is a variation of Albert Einstein's original quote, "Falling in love is not at all the most stupid thing that people do, but gravitation cannot be held responsible for it." A poster with the mis-quote, along a photograph of Einstein, has hung on my wall since my University of Washington days, in the mid-1980s.

Stanza four of "Because I'm Ninety-Nine Point Nine Percent Empty Space You May or May Not See Me Waving" is a direct definition of a nebula found on Spacecenter.org. If you visit this site, you can do the Galactic Word Find, and read definitions for all the words used in the puzzle. https://spacecenter.org/puzzle-galactic-word-find/

"It Takes Me Twenty Minutes to Traverse One Side of Dactyl": While Jumping Jesus may make you think of the song by Counting Crows, on their Underwater Sunshine (Or What We Did On Our Summer Vacation) cd, in my poem it refers to one of seed-spitting Popweed's (Cardamine hirsuta's) many nicknames.

Hawking Radiation, in the poem, "Standing in the Pasture, Thinking About Quantum Entanglement," is "the **thermal radiation predicted to be spontaneously emitted by black**

holes. It arises from the steady conversion of quantum vacuum fluctuations into pairs of particles, one of which escaping at infinity while the other is trapped inside the black hole horizon". For more on this, visit Scholarpedia.org: http://www.scholarpedia.org/article/Hawking_radiation

Before I wrote "Well, it's a Marvelous Night for a Moondance," I learned of this tradition: "In the Netherlands, city poets have responded to the tragedy of 'lonely funerals' by researching each deceased person and writing a tailored poem. The poems are short, stark, and moving speculations on identity and loss." From the *Ploughshares* literary journal blog post: The Dutch City Poets Who Memorialize the Lonely Dead. https://blog.pshares.org/the-dutch-city-poets-who-memorialize-the-lonely-dead/

"Unraveling Sorrow in a Tangled Multiverse": Nightshift is the name of a shawl pattern, https://www.ravelry.com/patterns/library/nightshift. The yarn I used was Entropy DK from Feederbrook Farm. Some of the color names are Chaos Theory, String Theory, Gravity, and Wavelength. You can find them here: https://www.feederbrook.com/shop/ENTROPY-DK.htm

About the Author

Poet and photographer, Ronda Piszk Broatch is the author of *Lake of Fallen Constellations*, (MoonPath Press, 2015), and two chapbooks, *Shedding Our Skins* (2008), and *Some Other Eden* (2005), both from Finishing Line Press. Her work has been a finalist with the Charles B. Wheeler Prize and Four Way Books Levis Prize, and she is the recipient of an Artist Trust GAP Grant. Ronda's journal publications include *Fugue, Blackbird, Tahoma, Passages North, Sycamore Review, Missouri Review, Palette Poetry*, and NPR News / KUOW's *All Things Considered*.

Ronda is a graduate of the University of Washington, with degrees in Creative Writing, Art, and Photography, and is currently a graduate student working toward her MFA at Pacific Lutheran University's Rainier Writing Workshop. She has taught poetry workshops to students from grade school to high school levels. She is a photographer (wilderness, occasional weddings, book covers, and portraits), and a digital artist, creating photo art collages, such as the image on the cover of this book. More photos and artwork can be found at www.fineartamerica.com/profiles/ronda-broatch. Visit her website at www.rondapiszkbroatch.com